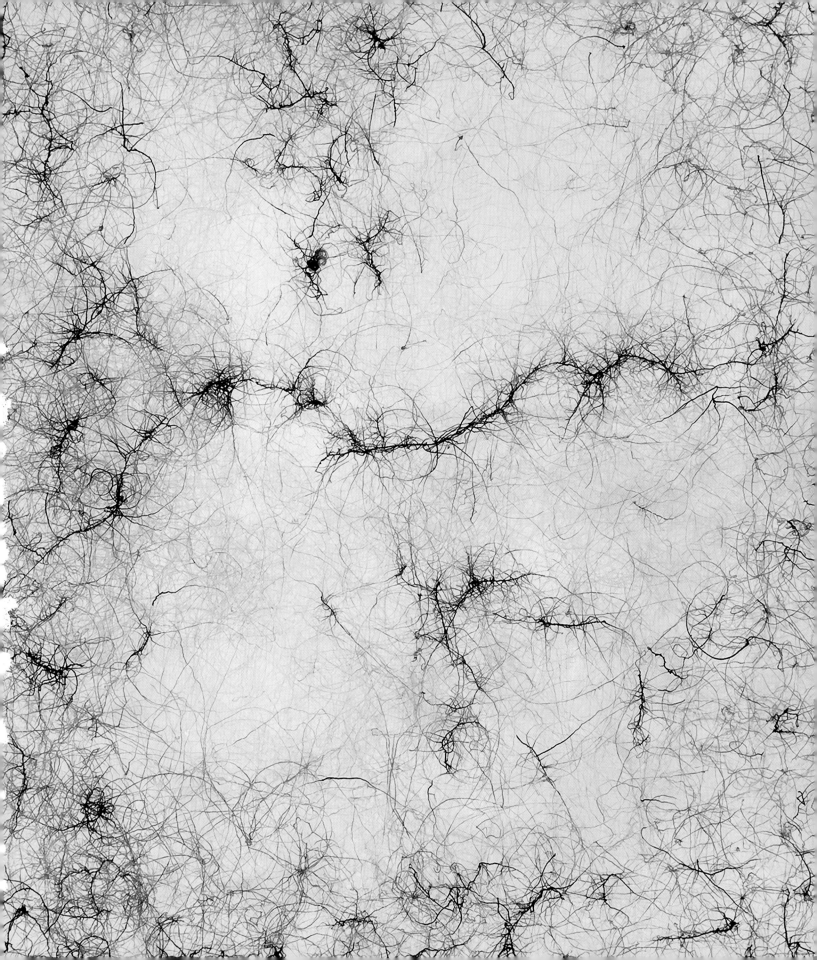

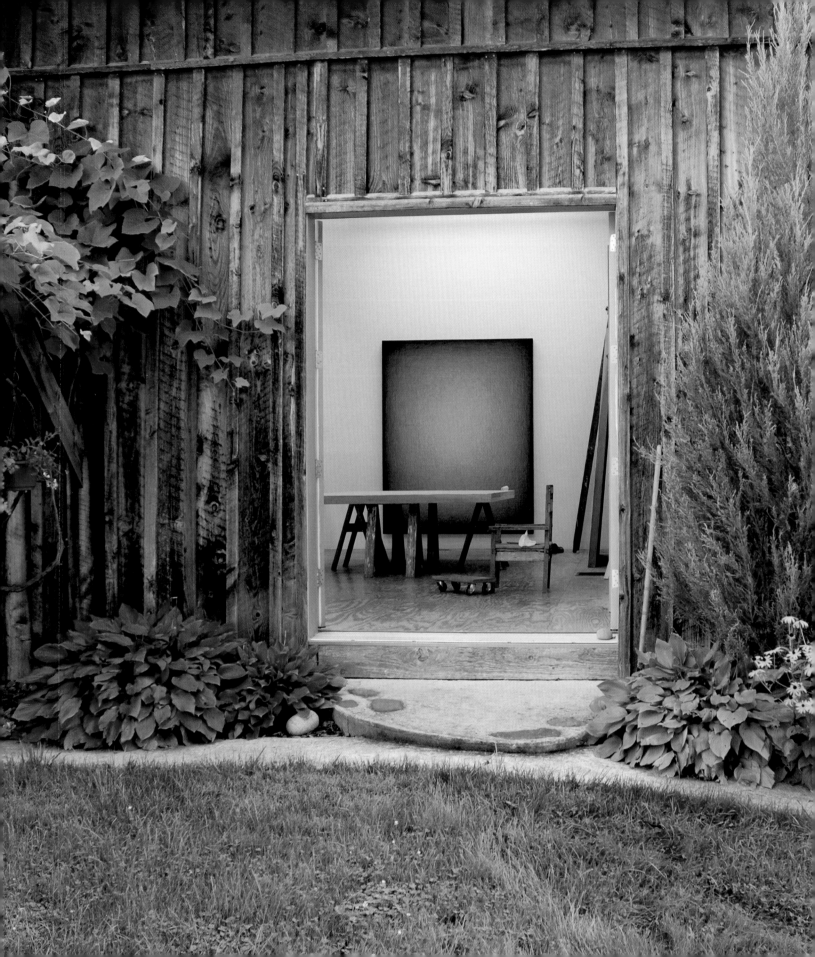

EMIL LUKAS

SPERONE WESTWATER
257 Bowery New York 10002
www.speronewestwater.com

Emil Lukas interviewed by Harry Philbrick

HARRY: Emil, tell me about this place where you live and work in Stockertown, Pennsylvania.

EMIL: There are two studios, each unique for the bodies of work that I make. I have a beautiful wooden barn – minimal, neutral, and with excellent light. It is a vintage 1864 chestnut beam construction with a great history. The barn is for making thread paintings and investigating how I can use color. It looks out across a trout stream to a second studio, #208, as I refer to it, where I execute and experiment with other works. #208 is a large, 14,000-square-feet, two-story manufacturing building with a cement floor and brick and steel I-beam construction. Everything else happens down there: puddle paintings, larvae paintings, sculptures, and drawings.

HARRY: The first time I came to the space, about twelve years ago, you showed me some of your stack sculptures. We ended up doing a project together based on those stack sculptures. Talk to me a little bit about the origin of those stacks and the process of making them.

EMIL: In the late '80s and early '90s, I spent time in Europe and North Africa. While traveling, I produced a large number of drawings. I felt that the accumulation of those drawings was visually more powerful than seeing one of them individually. When I came back to New York and settled into my studio at 125th Street and Lexington, a natural progression took place – I turned the drawings into paintings, turned the paintings into sculpture, and assembled them vertically into stacks. The stacks are 5 to 6 feet tall and relatively clean and spare on the outside. As I was traveling and working, I experimented with new processes and materials, some of which wound up in the drawings and paintings and subsequently became encased in the stacks. The objects become accumulations.

Where Roots Wander, **1993. Canvas, paper, plastic, glass, wood, cement, paint, plaster, 64 × 11 × 8½ inches. Panza Collection, Lugano, Switzerland.**

HARRY: Explain the process of making an individual stack – a stack piece from the outside looks like it's plaster or plaster mixed with other materials, and it might be ten, twelve, twenty layers deep. When you're starting with that first layer, that's one individual process and one individual experience; is the next layer on top based on that? Is it a continuation? Do you have some sense of where you're going when you make the stacks?

EMIL: I definitely have a sense of where I'm going because there are always traces or sections left from the previous layer showing where I've been. The stacks are all linked together in a timeline, a continuum of experiments, a kind of stratification. When you open a stack, you can only see one or two elements at a time. You flip through it like a book, restacking as you go. Then it's stacked upside down and you're left looking at the exterior, with the memory of the interior.

HARRY: Well, they're incredibly private. Of course, the process of making any work of art is generally a private process – in this case as a viewer I need you or your permission to unstack them and restack them, and so in that sense the work seems very introspective, perhaps more so than your more recent work. Which kind of reiterates what I'm driving at: when you see the stack and grasp that it is of a human scale, the experience is like confronting another individual in that what you get is mainly the exterior, with few glimpses inside. As you get to know that person over time, maybe over twenty years, you begin to understand what's really going on inside.

EMIL: There is an organic development that takes place within the stacks. One section influences the next or one element is a byproduct or a direct cast from the other. One section prepares you for another section. Nothing ever exists in isolation; the sections coalesce. If you take a section out of a stack and hang it on the wall or use it as an object on the table, it really makes no sense. It's completely out of context.

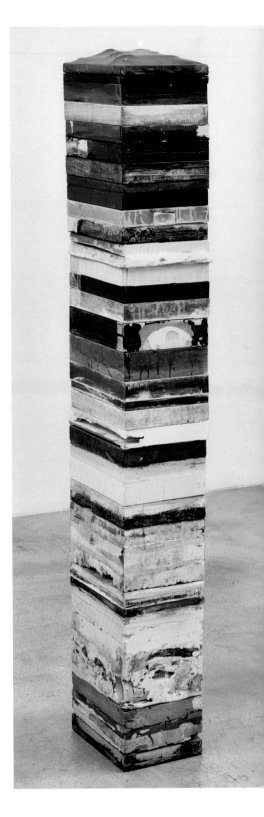

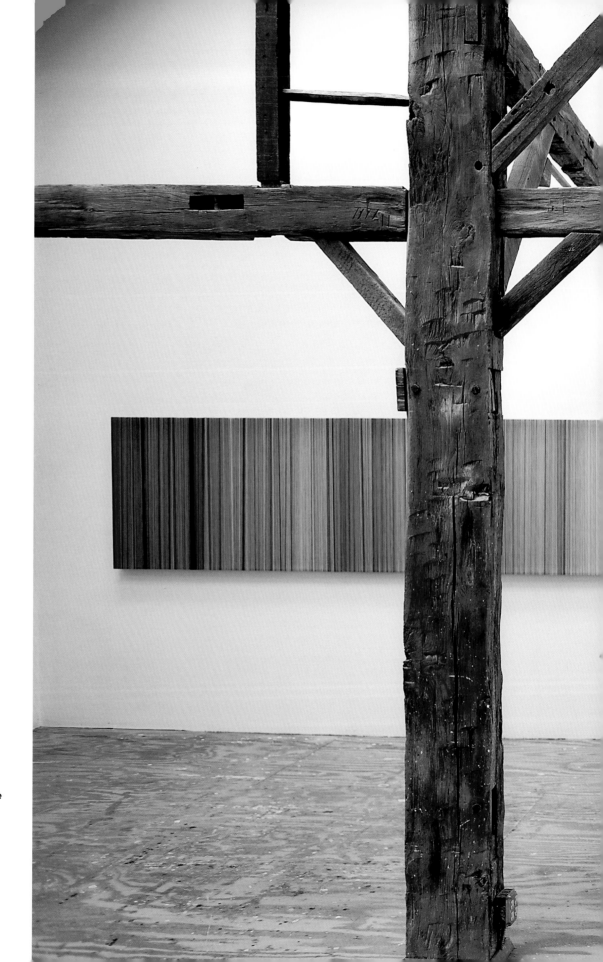

Studio view in the barn showing *Large Curtain* and two experimental stacks.

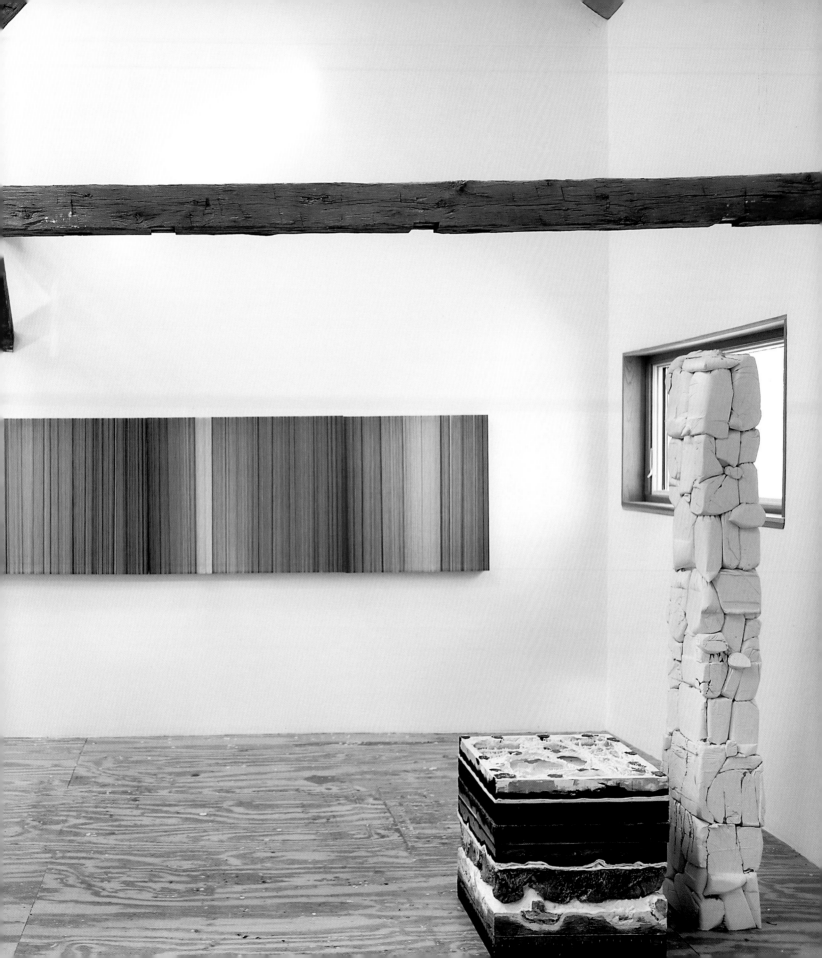

HARRY: So that privacy is inherent to the work, and it is an organic whole like a person, but in a way, as an outsider, you rarely ever get to know it. It keeps to itself.

EMIL: Yes, in the way that you have to view it, there is a certain fascination or frustration that occurs when you are confronted with only a small section at a time and forced to remember something else.

HARRY: So the very personal experience of the stack is unique among your artworks – it requires that level of intimacy. One of the key characteristics of the stacks you mentioned is that each one fits with the next; both metaphorically and literally they are formed against each other, so you're making molds, you're making impressions, things are touching each other and forming each other. What kinds of materials do you use in the stacks and how do they lead to other materials?

EMIL: In terms of materials, I like to experiment with whatever is around. This organic process led to the thread and larvae paintings. I was first attracted to thread when I traveled in Germany in the late '80s. At the time, the thread company Gütermann had huge racks with more than seven hundred spools in different colors on display in garment stores and drugstores. The dramatic visual effect fascinated me. I now have a similar rack in my barn. While the Gütermann threads are polyester, I've always had a fascination with silk. In 2011 I was fortunate enough to meet Ermenegildo Zegna, who acquired one of my thread paintings. He invited me to visit the Zegna mill in Trivero, Italy, and consider a commission. I was impressed by the working mill and the Zegna archives, which contained scholarly research about fiber, color, density, and pattern. I picked out a pallet of silk thread from which I made paintings, including those for Zegna and one now in the collection of Crystal Bridges Museum of American Art. Silk is very fine, thinner and more translucent, compared to polyester thread. These attributes allow me to make paintings that have a softer, more ethereal appearance.

HARRY: You mentioned that when you work you work alone. These may be my words, not yours, maybe it's a Zenlike moment or Zenlike experience that one has alone in the studio, a meditative experience. To me that

Studio view.

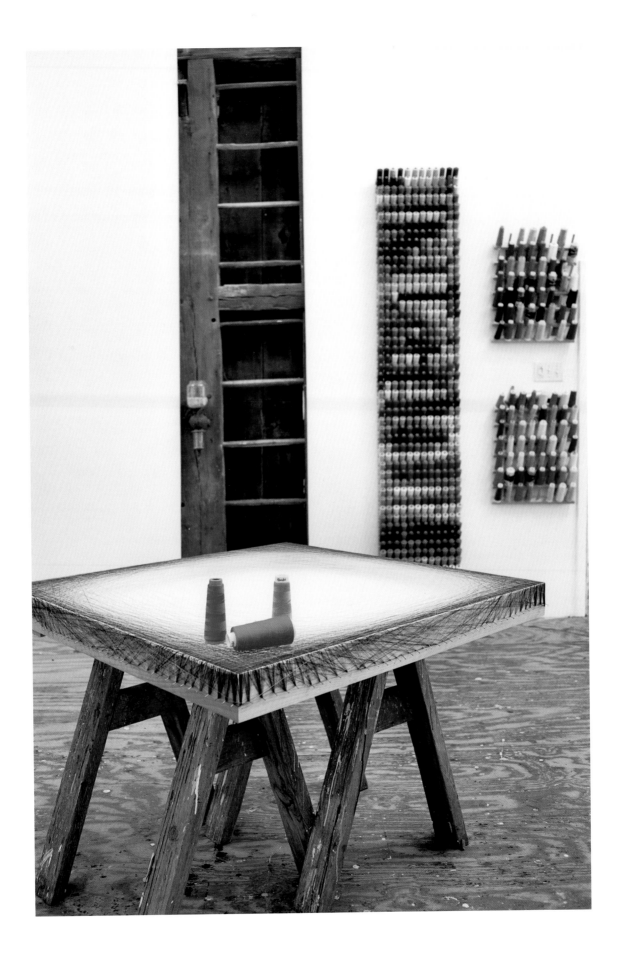

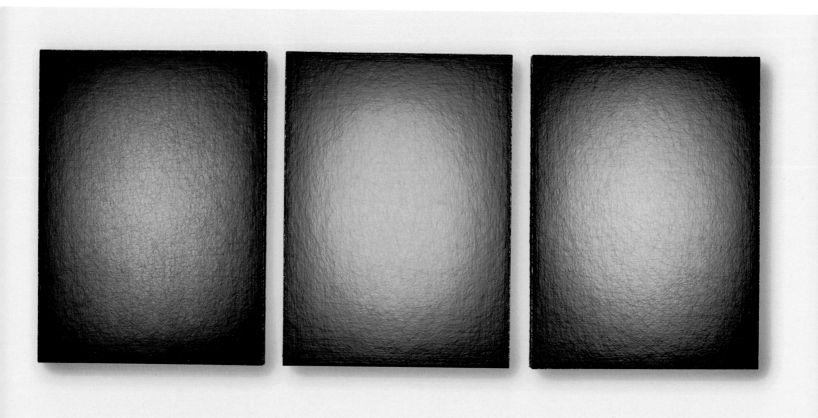

Zegna Silk Hum, 2012. Silk thread over wood
frame with paint and nails. Triptych, each
panel 32 × 24 inches; 32 × 78 inches overall.
ZegnArt Collection.

goes back to the concept of the Abstract-Expressionist painting where composition and creation are happening simultaneously. It's in the act of painting where creation happens. Have you had directions that you want to go in with those materials which collapse or fall apart?

EMIL: Sure. Sometimes those are the best moments. They force you to focus on what went wrong, what's happening, and where to go next. You need to surrender to the situation.

HARRY: You've shown extensively in Europe throughout Italy, Germany, France, and Switzerland. You've had more exposure in Europe than you've had in the United States as an artist. Why do you think this is so? What's different in the European context from the American context?

EMIL: Early on, Count Panza acquired my work and ultimately amassed sixty-seven works. The Panza Collection has been widely seen at the family estate in Varese as well as when on loan to many museums. My work tends to be a slow read, involving the passage of time. Being slower, it is more contemplative, and I think that seems to fit better with the European audience.

HARRY: We talked about the development of the stacks and experiments with various different materials. How did you start working with thread? I know the thread shows up in some of the early stack pieces, but talk me through the evolution of creating pieces entirely out of thread.

EMIL: There were a lot of experiments and questions. Why start on a preexisting surface, like canvas, fabric, or paper? I started collecting large amounts of thread to work with, paint on, and pin objects within. As the thread paintings developed and the scale increased, their optical effect became more refined and powerful. I wanted to use color in the smallest measurable mark. The diameter of the thread and the range of available colors influences the overall object.

HARRY: You talked about not wanting to start with a preexisting canvas. A painter would naturally say I'm starting with a canvas, I'll apply my gesso,

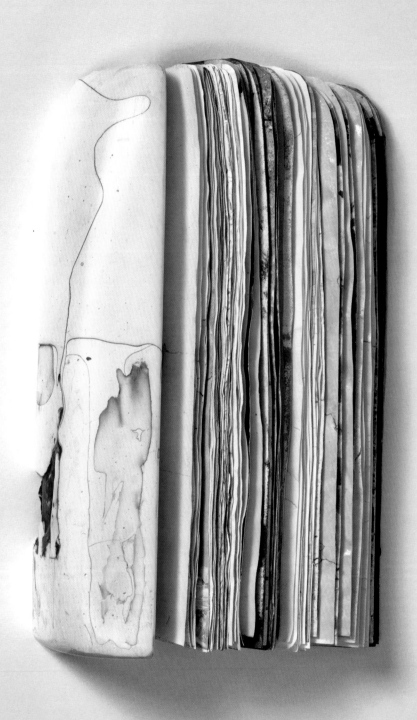

and then I'll make my painting whatever that may be. You're looking at it more as a sculptor asking, Why should this object be preordained; why am I why using this material? So, with the finished thread paintings, the viewer's experience of looking at them is first of looking at a painting and there's an illusion of depth or of radiation, and then there's this sort of ah-ha moment when you suddenly realize it's not what you thought it was. It's not a flat surface. You're looking into a surface that you thought was coming out toward you. This glow of white is actually recessed into the surface of the thing. So it raises the question as to whether these are paintings or sculptures?

EMIL: They are atmospheres.

HARRY: What do you mean by that?

EMIL: Well, they don't have a single surface. The paintings, due to their radial structure, are not on one plane. The depth from the front of the field of color to the white back is about 3 inches. The space in between is what I mean by atmosphere. Thread paintings engage with density, color, reflection, opacity, or translucence very much like an atmosphere does as light travels through it.

HARRY: So, in that regard, you could think of an artist like James Turrell, who uses and controls light to create an optical experience. You refer back to an artist like Monet, who optically uses paint through the juxtaposition of different depths of paint on the surface and by putting different colors near each other, but in both cases the observer's eye is finishing the process, so the end result occurs as your eye and brain process what you're seeing.

EMIL: I think the notion is to preclude a cursory look and encourage a closer inspection. The passage of time…

HARRY: Well, that goes back to what we were talking about before – the process of deliberation, that your work is a gradual read. One of the things that I love about your work is that it does slow the viewer down. Because

Water Marks (77 double sided drawings), 1992. Mixed media, 2 × 8½ × 3¼ inches. Panza Collection, Lugano, Switzerland.

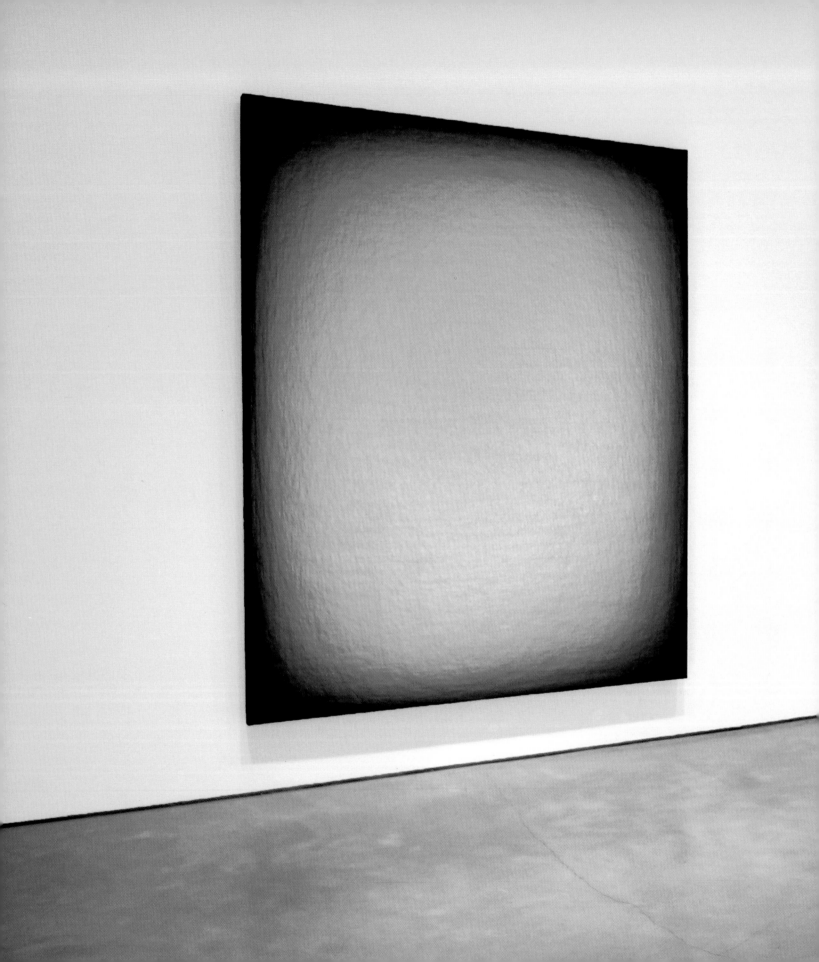

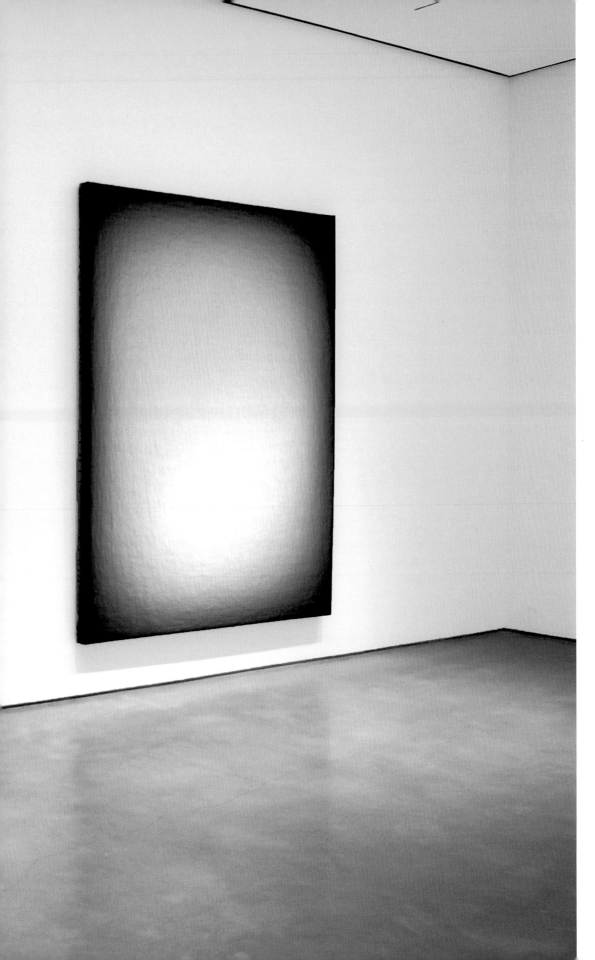

Installation view
"Emil Lukas: Larva, Bubble, and
Thread," 25 February–26 March 2011.
Sperone Westwater, New York.

Works (left to right):
Son, 2010. Thread over wood frame
with paint and nails, 96 × 78 inches.
The Dakis Joannou Collection.

Floating Bowl, 2010. Thread over
wood frame with paint and nails,
96 × 78 inches.
The Dakis Joannou Collection.

you have that moment where what was real is unreal and what was unreal is real. That process of realizing that you're not looking at a flat surface, you're looking at a dimensional surface. It gets you to stop and ask, Well, how did he do that? Then all of the sudden you're looking at the materials instead of a picture. It forces that jump from looking at what you think you're looking at, or looking at an illusion, looking at a picture, to looking at the artwork as an object, which to me is one of the most profound things an artwork can do: to get you to go from illusion to reality. However you want to define reality. That journey is one of the great journeys that an artwork can have, and you're managing to do that through materiality. I brought up the difference between the taut thread pieces and the dripped thread ones… Those meandering lines immediately bring to mind the larvae paintings. Clarify the process of making the larvae painting. How did you start collaborating with larvae?

EMIL: What is the most fascinating for me is that the larvae make a mark that I don't feel the human hand can create. Humans have a tendency to create rhythm, patterns, and equilibrium. The larvae's line is very "honest" — it is based on a natural reaction to the environment that I produce. Larvae tend to go away from the light and into the moisture. I establish an environment in which I know how they will react, such as working with all the properties that surround the larvae's movement: light, viscosity of the paint, dampness, or disorientation of the surface. Then I make the decision whether to keep the trace, paint over it, varnish and save it, whatever. This can take weeks or months.

HARRY: How are they physically moving the paint? How are they making a mark on the painting?

EMIL: That varies drastically. It basically depends on the surface and how many larvae occupy it. The painting can be totally dry with one drop of ink or with paint and ink so heavy it forms in puddles. I could use one, two, or ten thousand larvae, and they travel depending on the liquid.

HARRY: We talked a little earlier about the Abstract-Expressionist's notion of creation, the act of mark making inherent to the composition of the

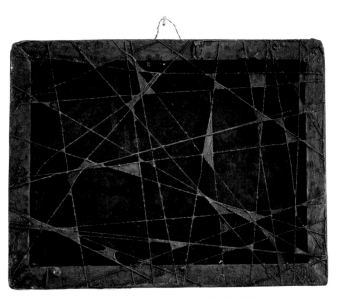

Inner Web, 1992. Double-sided, mixed media, 7 × 8 inches.

painting. In other words, you don't have a preconceived notion that you're trying to make marks to make it look like that. You're making the marks and discovering the composition through that process. In this case, with the larvae you're outsourcing to another vehicle. I don't know how animate they are, but explain that sense of control and then the lack of control concurrent with this process.

EMIL: Well, as far as the painting goes, the level of control is very high. When the larvae's mark making is complete, I can edit, paint out, under- or overpaint, save, and varnish. These actions can be repeated and overlaid.

HARRY: So back to the thread paintings, what was the first thread you used?

EMIL: When I was a child in Pittsburgh, where I was born in 1964, my mother encouraged art and crafts, but I only had access to yarn and heavier embroidery threads. It was not until I encountered the Gütermann threads in Germany in the late '80s that I started to use the thread. *Inner Web*, a

Installation view
"Emil Lukas: Larva, Bubble, and Thread,"
25 February – 26 March 2011.
Sperone Westwater, New York.

Twine, 2010. Ink and paint on canvas,
two panels, 97 × 57 inches each.
Private Collection.

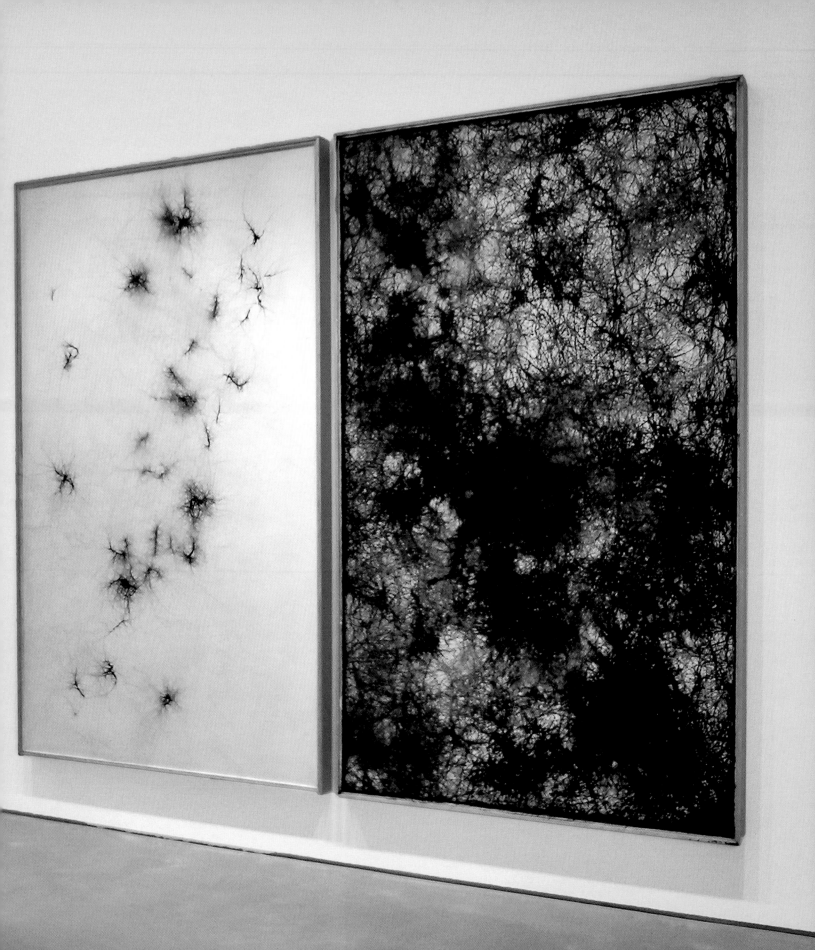

mixed-media painting from 1992, is made of wood, paper, thread, plaster, paint, and wax with wire and nails for hanging. It is the earliest work in which the composition consists of a balanced but random network of thread. Thread is wrapped around the wood frame and painted. Paper is placed over thread and poured with plaster from the back, forcing the composition to bulge forward, similar to how the recent thread paintings radiate out or in. This energy is then frozen on the other side with layers of paint.

HARRY: Do you see any relationship between the thread paintings and weaving and/or knitting, which are two very separate activities?

EMIL: No, I don't actually. For me the thread paintings are about color. They're about compositions of color, light, reflection, and opacity. They're much closer to formal wet-on-wet watercolor paintings than they are to anything in the textile field.

HARRY: It's interesting, because working with watercolor is very different from working with oil paint. With oil paint you can build up and build up. With watercolor you have a limited opportunity to do that and it can go off the rails really quickly, and that gets me to thinking about how you mix color with the thread pieces, because it seems as though it's somewhere between mixing color as you would with paint and mixing color as you would with light, which is very different — often the opposite.

EMIL: We all know about formal complementary color relationships. If you want to make the blues pop a little bit you put some muddy browns and oranges around them. Thread does not behave like that, like paint. Its optical effects are difficult to predict. I have to concentrate, witness the changes, react, and look again. What shocks me is how one thread can completely shift the look of a painting.

HARRY: As a viewer it's surprising, because in some of the large thread pieces where there's really a glow of white in the middle, from a distance you see a kind of gray around the side. When you go to look

at the colors that are making up the gray, it's nothing at all that you would expect.

EMIL: No, there's no gray. Figuring that out and seeing that development keeps the paintings challenging to make. I don't even want to say "make" because my process is more like playing an instrument or a game. Like watercolors, the more thread that's added, the more opaque it gets. Then the color starts to change and you read it in a different and complex way.

HARRY: Well, playing is an interesting notion, because you would expect, looking at the sides of the paintings where you can see the nails that are holding the thread in place, you would expect a kind of a regular grid, and yet it isn't a regular grid. The nails are spaced at random intervals. Sometimes they're close to the front edge of the piece; sometimes they're not. They kind of meander along, suggesting an organic process. Having been in the studio and seen your setup, I know the paintings are flat – they're horizontal when you're working on them. You're moving around them looking down on them, so it is a very different relationship that you as maker have than we do as viewer, and I just wanted to note that. One of the things that visually links the large larvae pieces and the large thread pieces is the sense of looking through a scrim of lines to a deep space. Talk to me about the importance of that illusionistic space. It's something that you create over and over again.

EMIL: I'm not concerned with reproducing the repetition found in nature. What results comes from another level, from deep in my subconscious. It is an intuitive process. You are in a moment and there is a flavor, a sense, a smell that forms an image in your mind. It's something very universal, impossible to explain. Maybe it seems cliché, but I want to paint nothing while painting everything. I want people to see something in them, but I don't want to predetermine their experience.

HARRY: Words that come to mind are – maybe *sublime* is a good word. We talked about a meditative state in terms of making the work, but there is that universality created out of the most mundane materials. We are brought

back to the fact that this is the trail of larvae, this is a piece of thread, that using these very mundane materials you are able to create a universal and expanding visual phenomenon. That kind of ironically brings me right back to the stacks, which remind me of the kind of innocence of being a little kid – like the first time you pick up a seashell and put it to your ear and there's this whole other world there. That childlike process of discovering infinity in the most mundane materials seems to be really at the heart of what your project is all about.

EMIL: Harry, I think you get it.

Harry Philbrick is the Edna S. Tuttleman Director of the Pennsylvania Academy of the Fine Arts. While Director of the Aldrich Contemporary Art Museum in Ridgefield, Connecticut, from 1996–2010, Philbrick curated a show of Emil Lukas in 2005.

Floating Droplet, 2012. Silk thread over wood frame with nails, 64½ × 81 inches. Crystal Bridges Museum of American Art, Bentonville, Arkansas.

overleaf: *Large Curtain*, 2013. Thread over painted wood frame with nails, five sections, 36 × 252 inches overall.

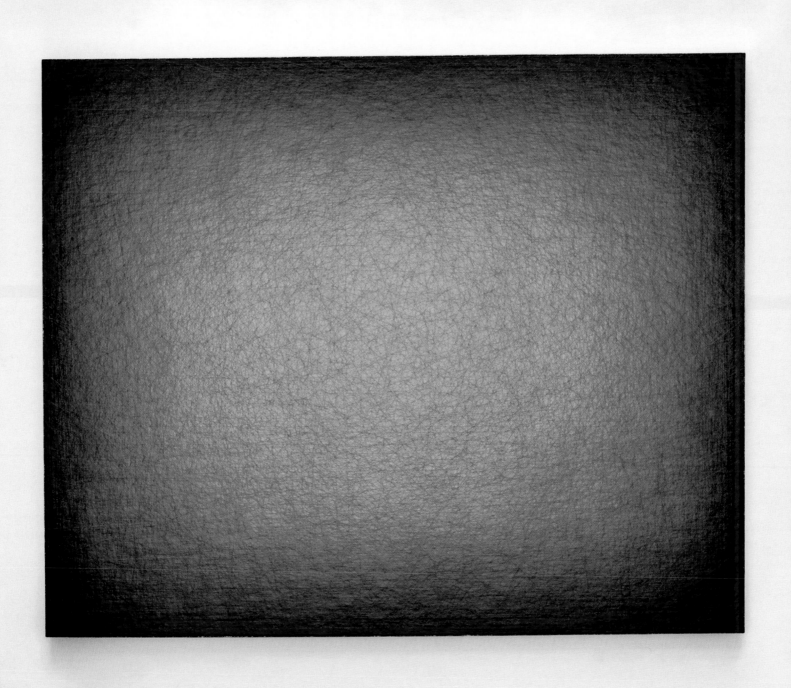

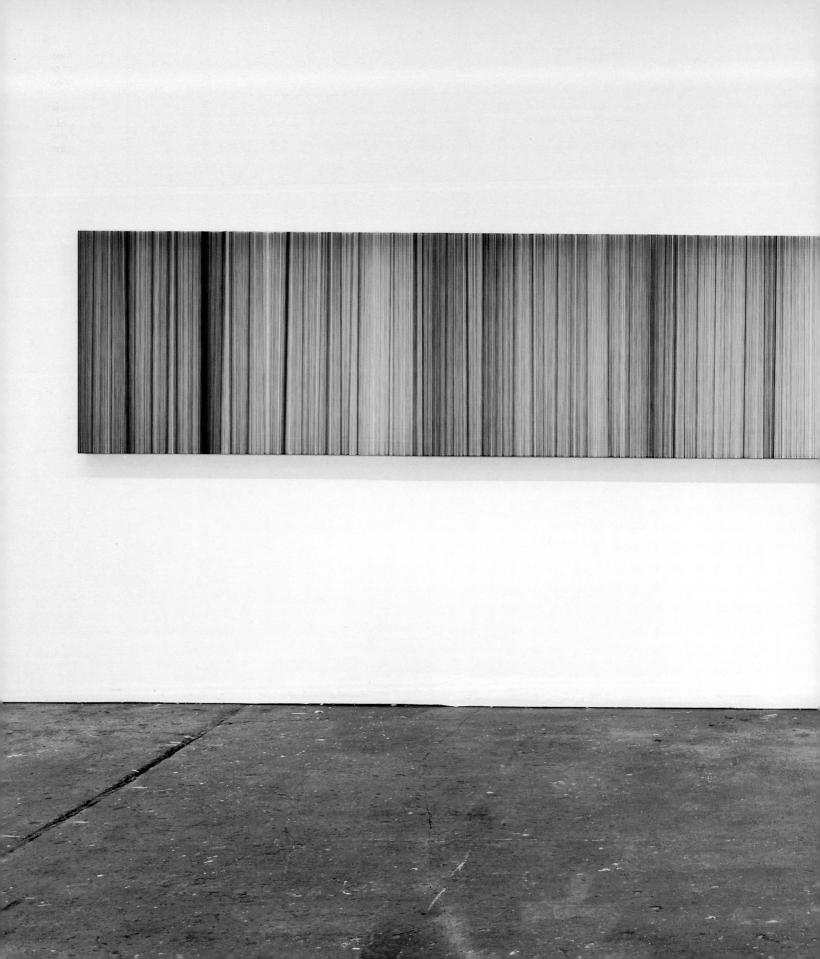

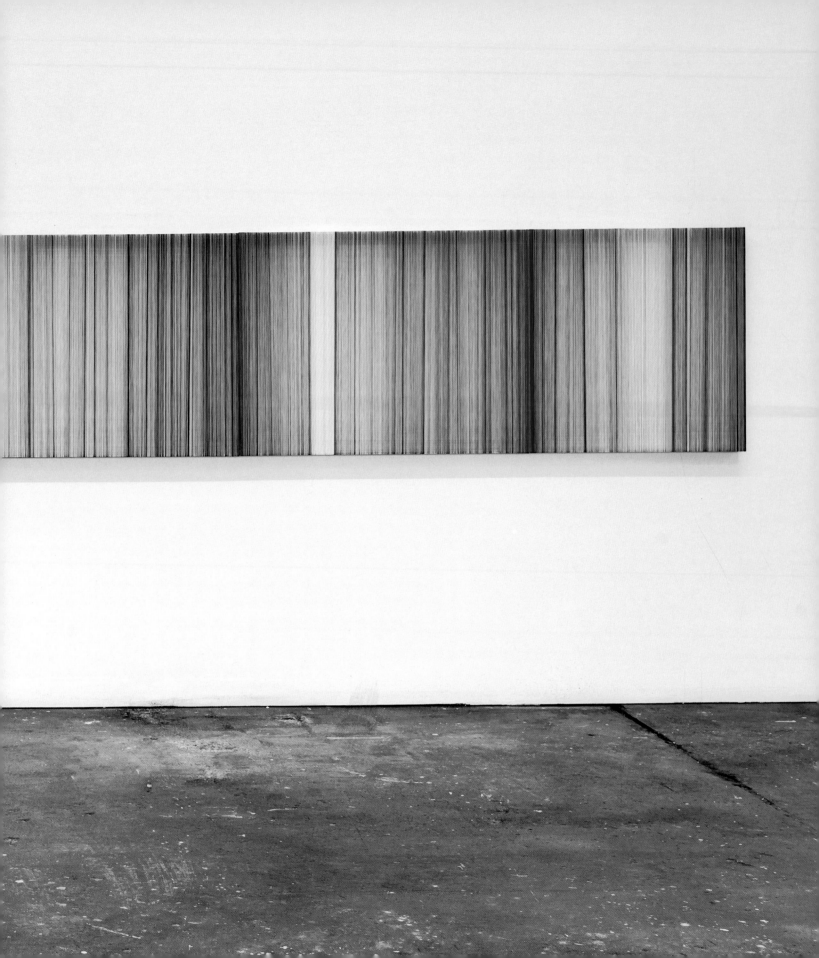

Horizontal White, 2013. Thread over painted
wood frame with nails, 78 × 96 inches.

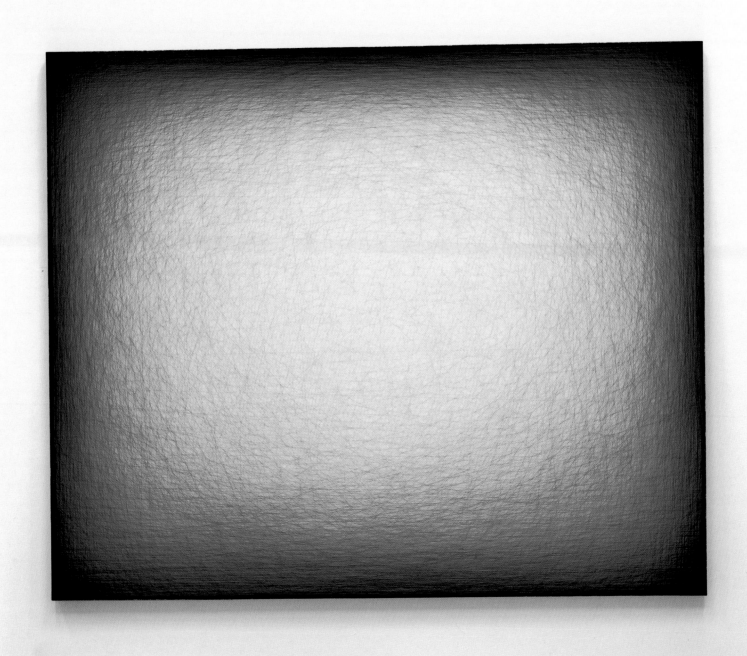

Artillery or Poppy Red, 2013. Thread over
wood frame with paint and nails, four parts,
51 × 51 inches each; 107½ × 107½ inches overall.

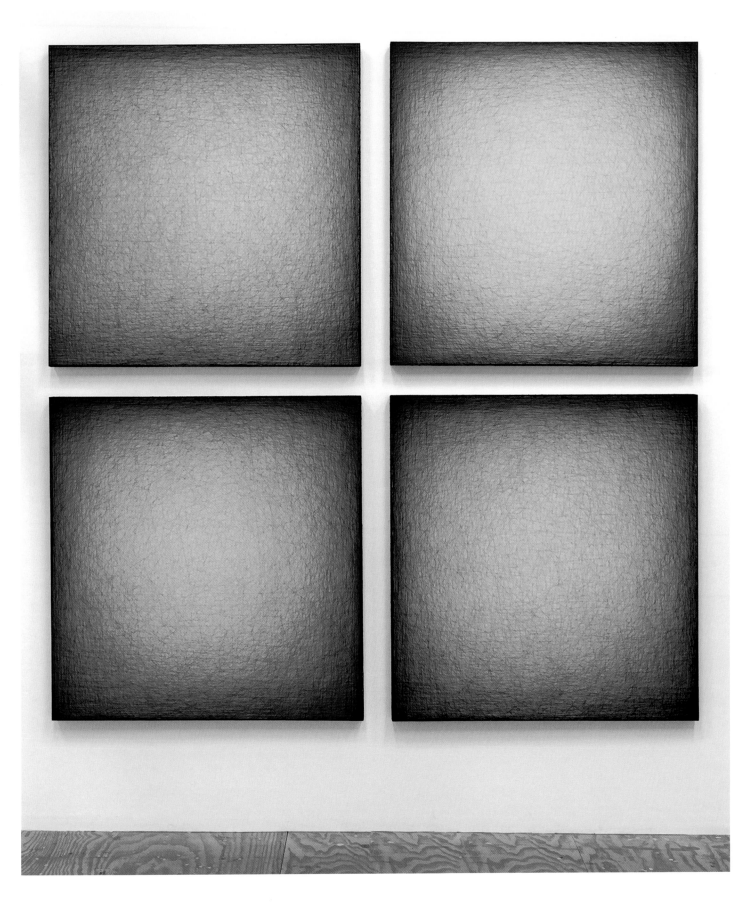

Heavy Gas, 2013. Thread over wood frame
with nails, 16 × 14 inches.

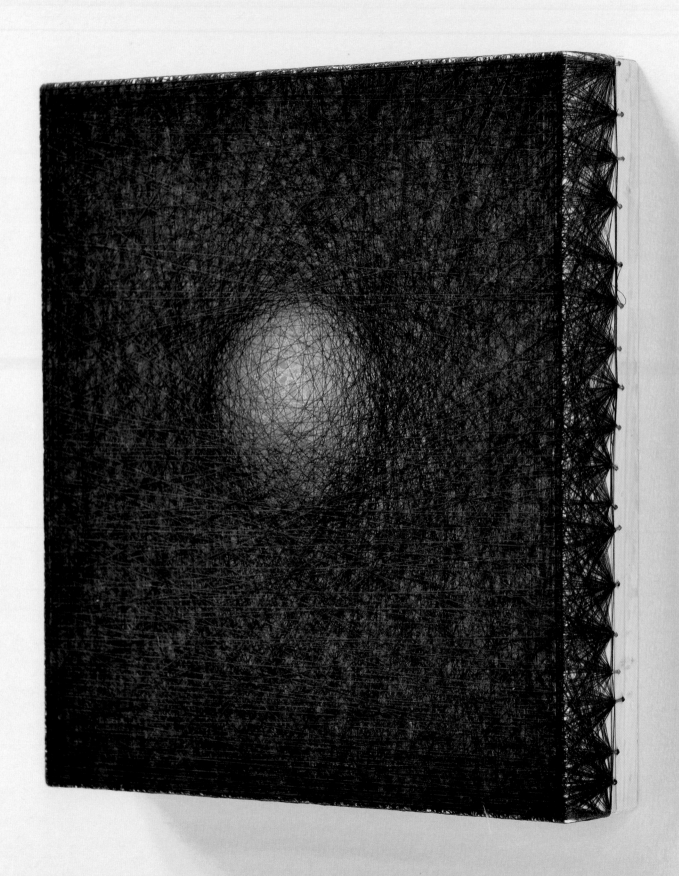

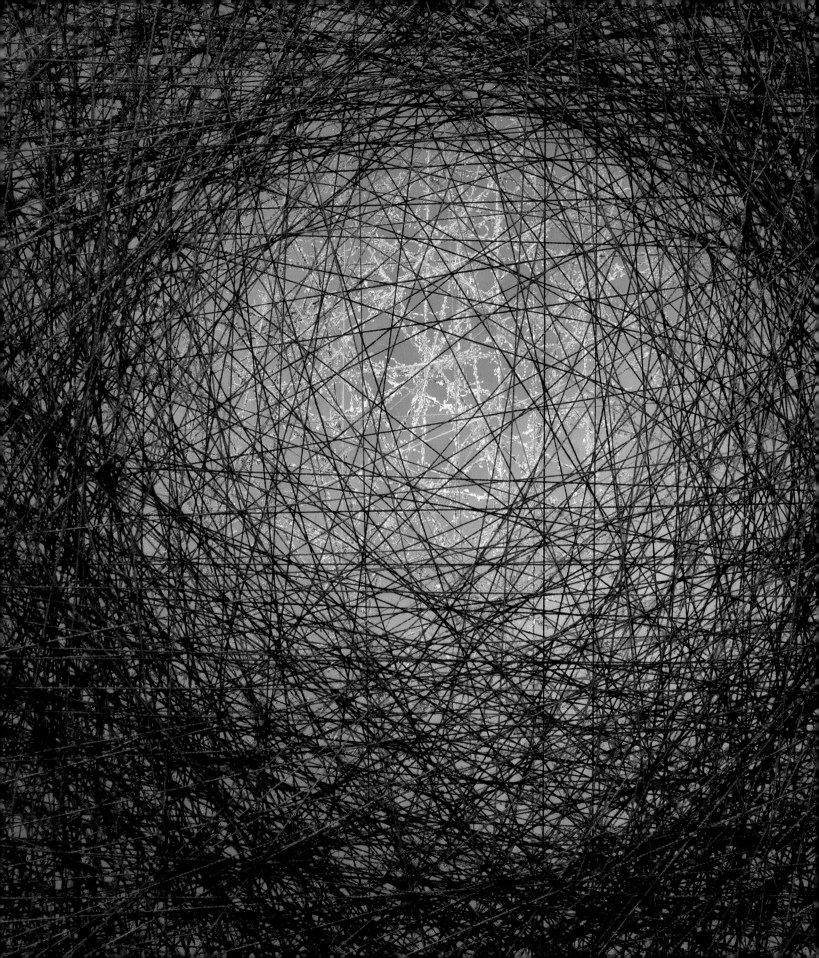

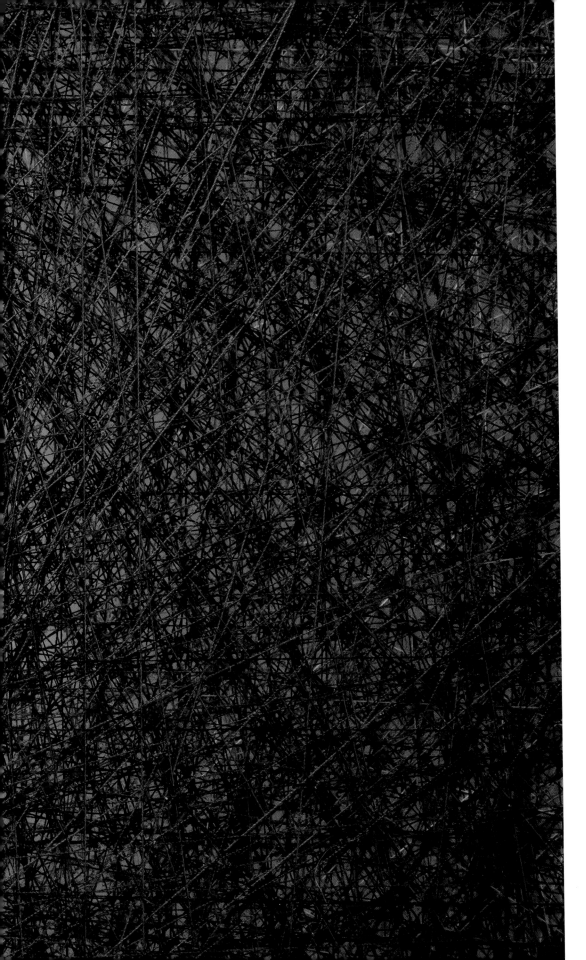

Detail, *Heavy Gas*, 2013.

Red Gas, 2013. Thread over wood frame with
nails, 16 × 14 inches.

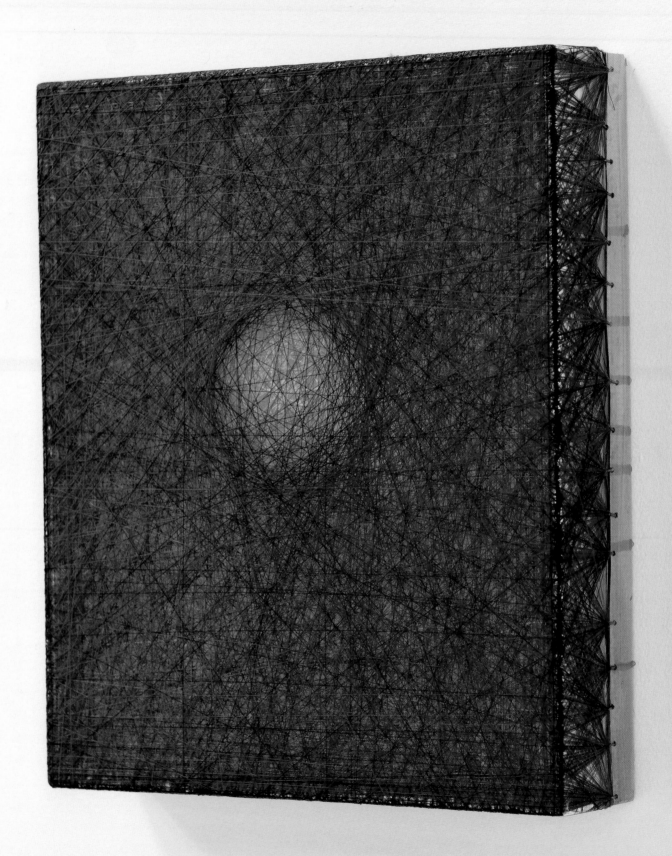

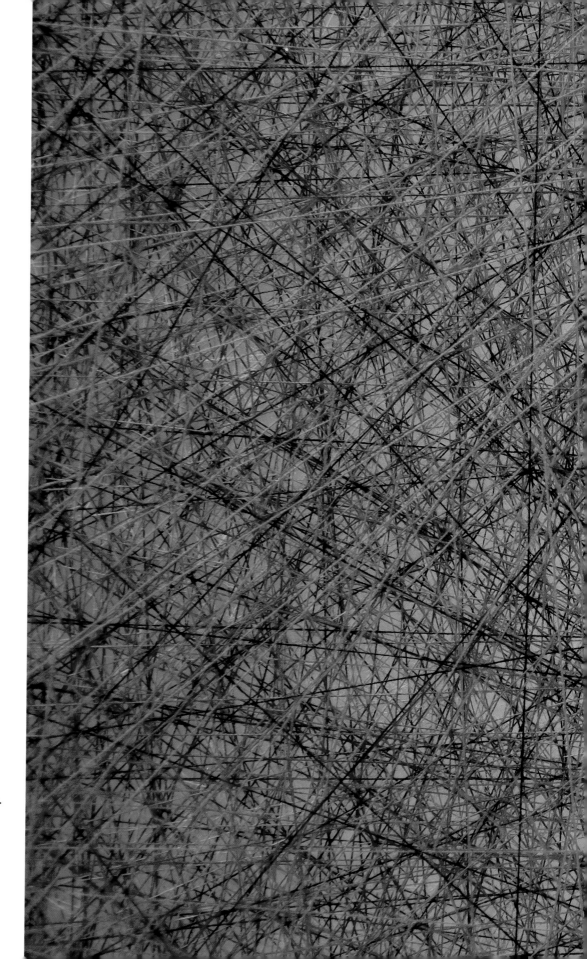

Detail, *Red Gas*, 2013.

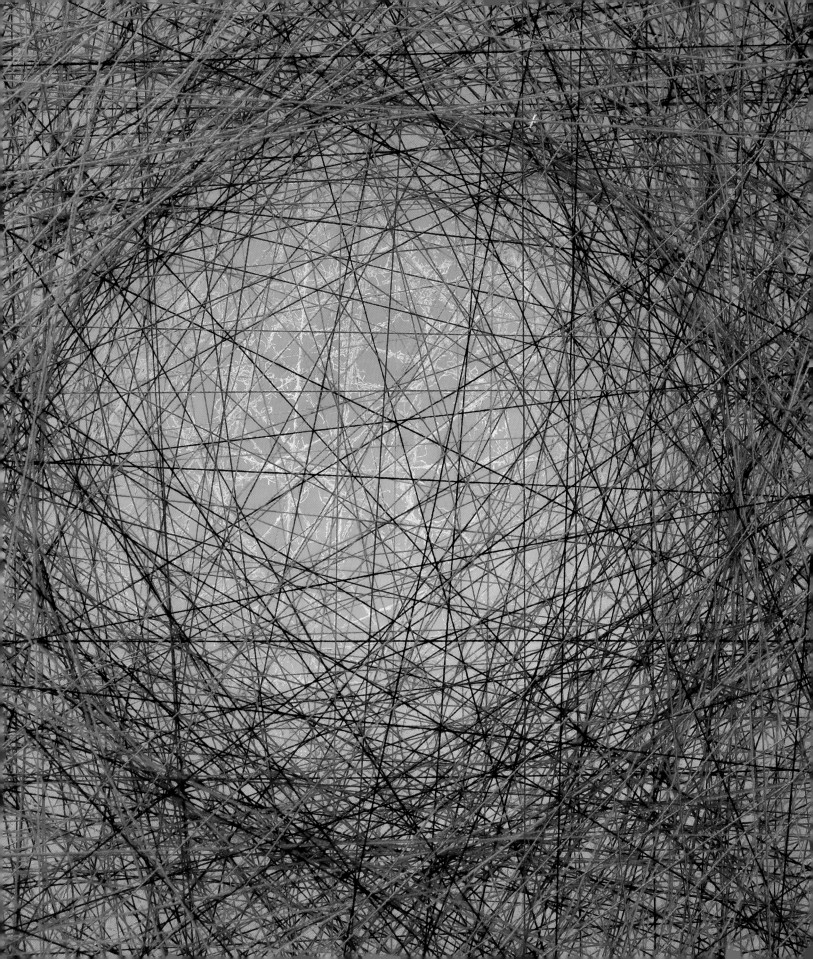

Rain, 2013. Paint and ink on canvas over wood frame, 78 × 97 inches.

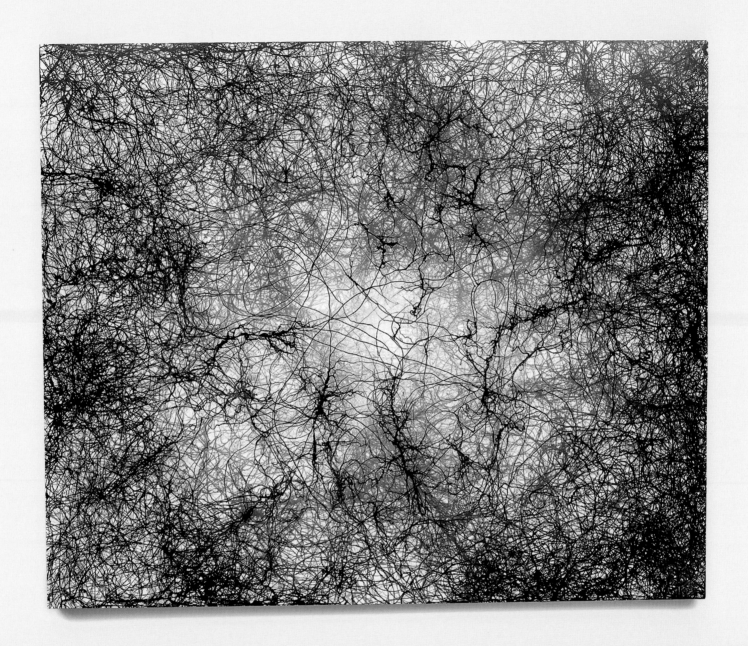

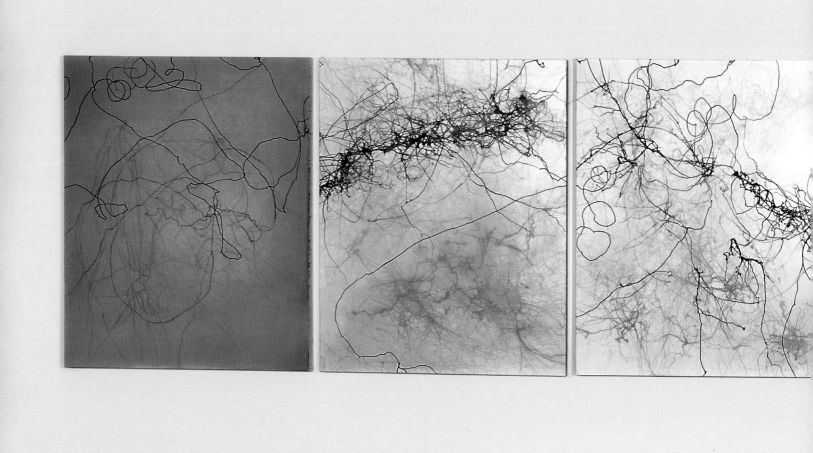

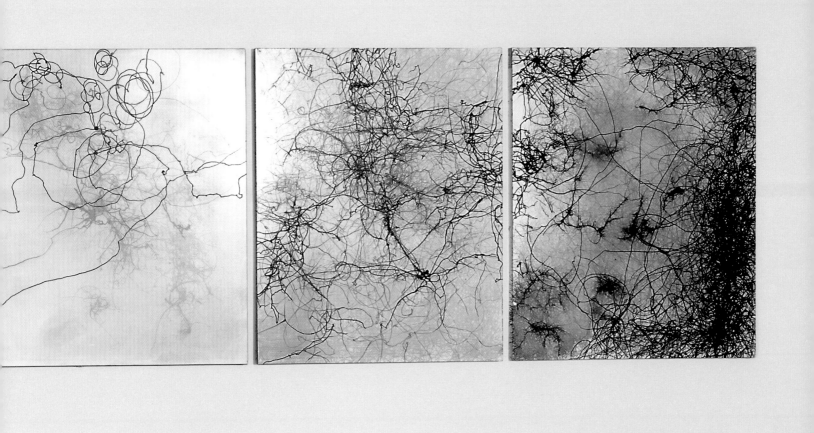

preceding overleaf: *Liquid Reflector 1–6*, 2013. Ink and paint on canvas over wood frame, 48 × 40 inches each.

Cloud, 2013. Paint and ink on canvas over wood frame, 96 × 78 inches.

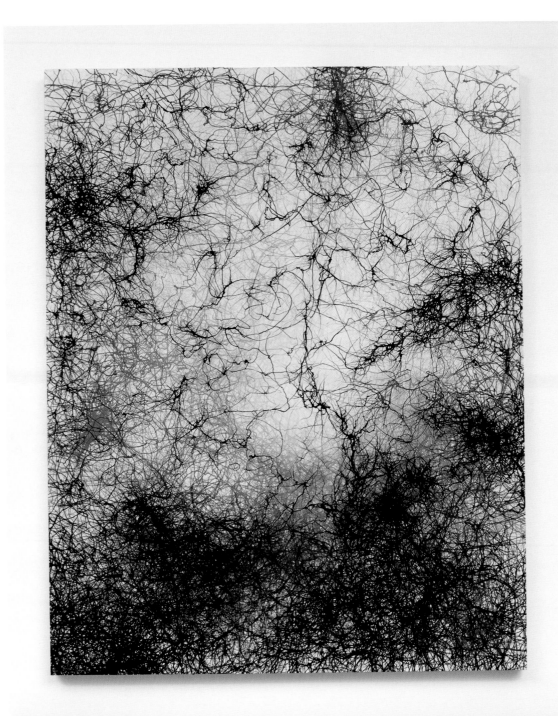

Lite Messenger, 2013. Paint and ink on canvas
over wood frame, 96 × 78 inches.

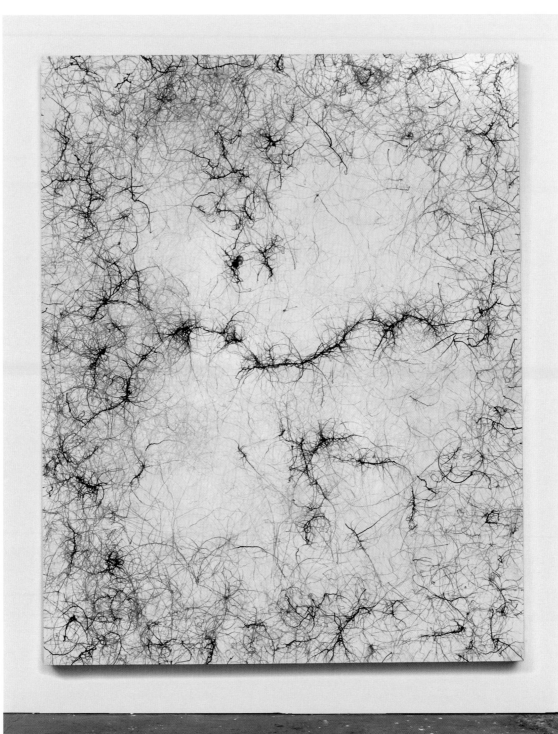

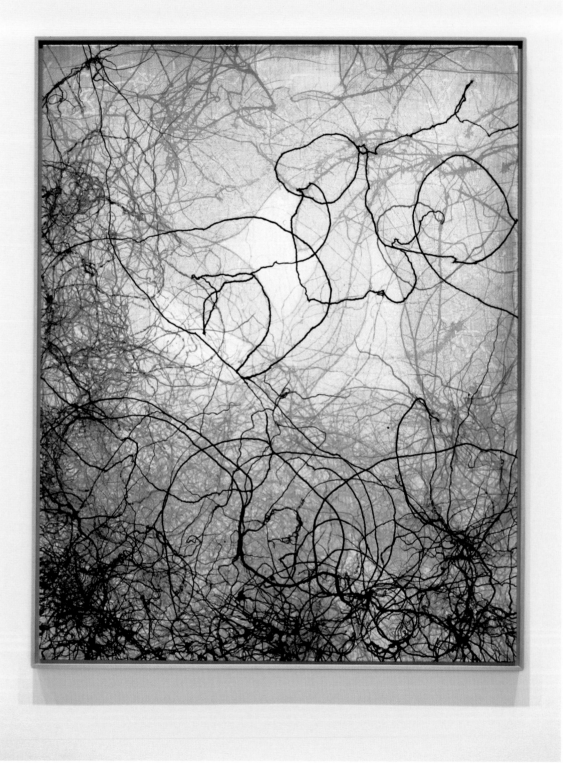

Humid Base, 2013. Ink and paint on canvas
mounted on wood panel, 41¼ × 33⅛ inches.

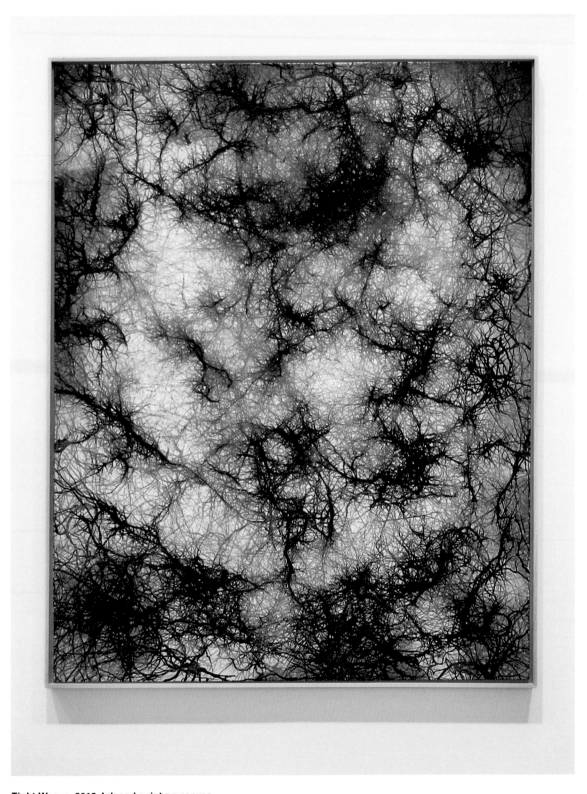

Tight Weave, 2013. Ink and paint on canvas
mounted on wood panel, 41¼ × 33⅛ inches.

This catalogue was published on the occasion of the exhibition "Emil Lukas" at Sperone Westwater, New York, 9 January–22 February 2014.

All artworks © Emil Lukas

Photography credits: cover, pp. 1, 2, 16, 23, 24, 25, 27, 29, 31, 32, 33, 35, 36, 37, 39, 40, 41, 43, 45 by Zach Hartzel; pp. 5, 12 by Alessandro Zambianchi; pp. 6, 8 by Luke Wynne

Cover: Detail, *Large Curtain* (p. 24)

Page 1: Detail, *Lite Messenger* (p. 45)

Frontispiece: View of studio barn

ISBN 978-0-9892299-2-0

Design: Laura Lindgren

Printed by Puritan Capital

Published by Sperone Westwater, 257 Bowery, New York, NY 10002